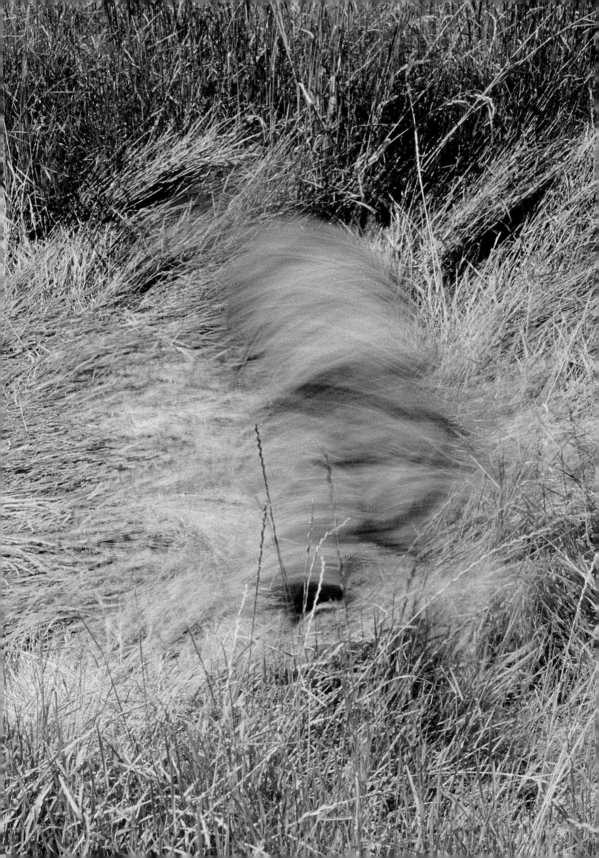

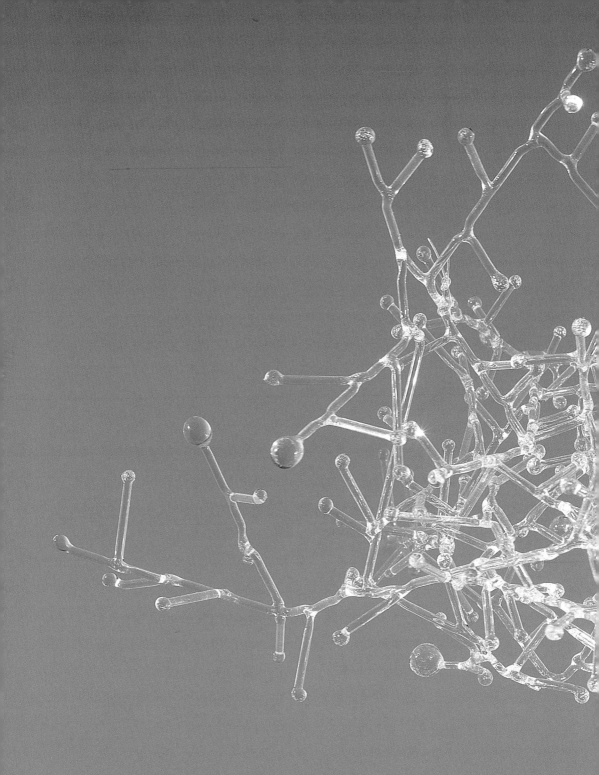

ALYSON SHOTZ

A SLIGHT MAGNIFICATION

OF ALTERED THINGS

IAN BERRY

THE FRANCES YOUNG TANG TEACHING MUSEUM AND ART GALLERY

AT SKIDMORE COLLEGE

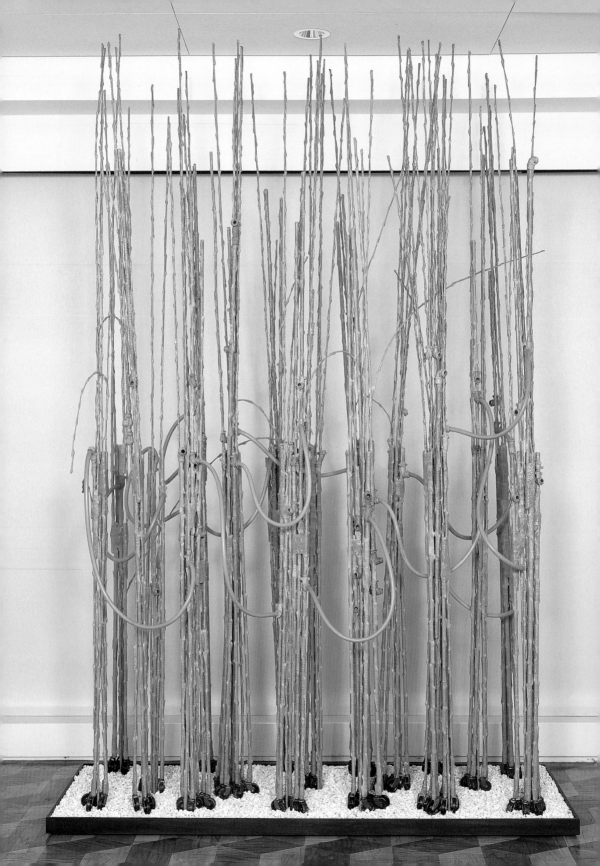

A SLIGHT MAGNIFICATION OF ALTERED THINGS

A Dialogue with ALYSON SHOTZ by Ian Berry

An examination of our surroundings is at the heart of the multi-layered artwork of Alyson Shotz. Through elegant organic forms and decidedly unnatural materials, she addresses the history, politics, science, and aesthetics of our environment with an even hand. She neither preaches nor shies away from confrontation. Her work supports conversations about such things as genetic engineering, bio-diversity, pollution, and our human desire to control "nature."

Shotz is a builder. Her paintings are made with successive pours of resin; her sculpture is taped, waxed, and bunched; her outdoor fence is laminated, bolted and set; her animations are drawn; her photographs are staged; and her digital works are collaged—all processes that begin with the fitting marriage of material and idea. As in her important 1997 video and photo series *Reflective Mimicry*, Shotz, as an artist, puts on a variety of costumes and sets out to explore, becoming a seamless participant in the activity of the natural world.

IAN BERRY Nature has been an important subject of your artwork since you were a student. I know you have researched the idea of nature from different time periods and have created a timeline for yourself of how the concept of nature has evolved. What interests you about the multiple meanings?

ALYSON SHOTZ I have been most interested in the suggestion that nature is purely a human construction. Part of my work springs from my interrogation of that seemingly contradictory idea. The word nature changes its tone and implication in different eras. The Victorians saw it as a kind of collectible—status being conferred upon those who were able to possess the most diverse specimens of flora and fauna from around the world. The Hudson Valley School of painters saw nature as a spiritual inspiration, a biblical allegory, majestic and unspoiled, though we now know

(title page)
Branching Study, 2002
Flame-worked pyrex rod
12 x 20 x 2"
Courtesy of the artist and
Mixed Greens, New York

(facing page)
Mobile Flora, 2000
Steel rods, wood, Q-tips, floral tape, latex rubber, casters, electrical and plumbing parts, rubber tubing, stones
108 x 144 x 72"
Collection of Eileen and
Peter Norton, Santa Monica

that they intentionally cropped out signs of encroaching industrialization in many of their paintings, making it seem as though New York State was a wild and untamed place in the late nineteenth century, even though it was not. Dutch Renaissance still life paintings depict fruit and flowers in various states of life and decay symbolizing the life cycle of humans and all living things. British Natural Theology of the eighteenth century taught that God bestowed nature as a gift to humans—everything was created for us to use. Nature has been an integral part of our consciousness since the beginning of recorded human thought: cults of nature, nature based religions, nationalistic symbols. Through my work in sculpture, photography and painting, I am continuing in this tradition of seeing culture through our perception of nature.

IB In addition to your thinking about culture from a humanistic point of view, you must also read a great deal about science. How have advances in scientific research influenced your work?

AS I started making this artwork during the early 1990s when research into bioengineering and genetics seemed to be just coming to fruition. Occasionally you'd read an article or hear a report, but it was not the subject of common conversation yet. At that same time, the internet was becoming a tool of common use and it seemed that we were entering a very new futuristic world where boundaries of all kinds were being broken down—boundaries between people, as well as physical boundaries between species.

IB This idea of boundaries breaking down seems to be a key component for much of what you continue to work on both materially and conceptually.

AS I began to explore the notion of the disintegration of species boundary in some early work from 1994, in particular, a group of photographs called *Details*. The process of making them was extremely important to the work. The process related notions of digital versus analog in relationship to natural versus unnatural.

IB They look like blown up images taken through the microscope.

AS They actually began by scanning actual objects, not photos, into the computer using a video camera. Some were small models I made out of plasticine, some were plastic things picked up on the street—none of the things were living. After scanning the objects, I'd recombine and work the images in the computer until they looked like photos of living things. I'd then make a photo-negative from the computer file and make the final print as a regular silver gelatin print. The images had therefore gone on a long journey from dead to living and from analog to digital to analog again.

In addition to the confusion between live/dead, analog/digital, there is a conscious misleading of the viewers perception—is it magnified? Is it large and shrunk smaller, what is the size? What is it I am looking at? This notion of confusion of materials... blending of materials back and forth through media, and confusion of image is important and continues to be important in my work.

Outside inside, inside out, 1996
Gouache and ink on paper
with wire, sculpey, and
false eyelashes
9 x 33'
Installation view, Susan Inglett,
New York

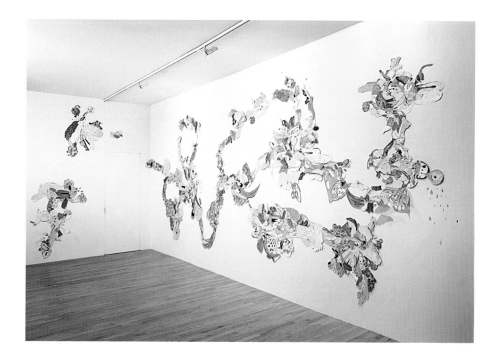

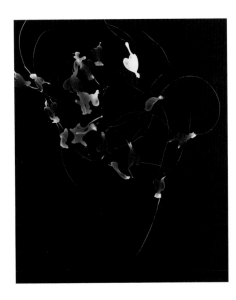

Fly Tracks Five, 1999
Photogram
24 x 20"

IB You use all sorts of media—how do you choose which tool or material to create something with?

AS I think of myself as a visual and conceptual artist—meaning that I believe in making artwork that privileges the material, formal and visual aspect of artmaking while it at the same time articulates a specific concept or idea. I choose a medium as an extension of the concept. If painting my idea proves to be the best way to interpret that idea, then I'll utilize painting, if it seems to be video, then I use video. I see art as a process of exploration and discovery. Sometimes I may explore the same idea in different media to better understand that idea or to better understand what it is that I find resonant. So, for example, at the same time that I was making those photos, I was also drawing. The drawings had the same conceptual framework as the photos, but in addition, I was interested in exploring some formal issues about drawing itself— did it have to be flat, could it be sculptural, could it be another shape besides a square? Could the shape of the drawing determine itself? All of the pieces from that period have relief elements, but some were purely sculptural, not like regular drawings at all.

IB You also delved into performance, video, and sound with your work *Reflective Mimicry*. It remains your most often shown work. Disintegration seems to be at work in this work as well.

AS My focus had begun to shift away from the question of natural versus unnatural to an exploration of the physical boundaries between myself and the outside world, what separates me from an animal or plant, and where are the conceptual boundaries? Will the Linnean classification still apply with the advent of genetic engineering? I became interested in the idea that the boundaries between things had become more permeable—that there was a

sensation of organic bleed. I wanted to express the confusing perceptual sensation I had that there was a kind of psychic as well as physical seepage of the body into the landscape and landscape into the body. I hoped to create and be inside an optical continuum that would relate back to the physical continuum I experienced. I also wanted to include myself more directly in my work. Drawing felt like it was removed from experience, and I wanted to be physically involved in this project, so I created this mirrored suit with hand and back pieces that would allow my boundaries to become blurred and would extend my reflections out into nature. Using the suit and a model, I shot a bunch of photographs and video that play with the idea of loss of figure/ground—the figure dissolving into the landscape.

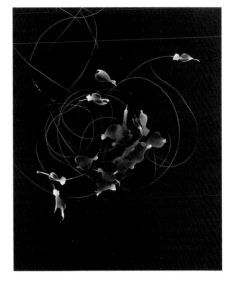

Fly Tracks Six, 1999
Photogram
24 x 20"

IB Can you talk more about the idea of reflection and mirroring?

AS Mirrors can function as an almost physical, ongoing abstraction. They contain fleeting events, and in a way, by containing movement, they contain or portray time. Robert Smithson wrote in his notebooks that "mirrors represent the containment of our environment and simultaneously its displacement. They are imprecise reflections suggesting the difficulty of pure seeing." We can try to see nature or nature is reflected in us but it is always distorted. I have always been especially intrigued by Smithson's *Enantiomorphic Chambers*—a little known piece not in existence anymore. It was a sculpture about the size of a basketball in two parts, with mirrors on the inside of each half. The viewer was supposed to stand with his head in between the halves so that in looking, he would basically disappear into the reflections. Like Alice in Wonderland we are put in the position to ask 'what side of the mirror are we on.' In a similar way, the mirrors on my reflective suit confuse and blend earth, sky and body.

IB Like camouflage, the model disappears in this work only to become visible at the very end when the camera zooms out a bit and you see the figure holding the flat mirror mask. You instantly realize that the slithering shapes you have been looking at are human, like stepping out of camouflage.

AS I like when that disappearance occurs—when there are no divisions between things. This creates an imbalance that allows the inorganic, in this case the suit, which is crystalline and symmetrical in structure, to bleed into the organic, the trees, leaves, and grass of the setting. But this also happens psychologically, for instance the landscape around us is something we see as outside ourselves even though it may only be a mental representation of what we experience inside due to our biology—the way our brains are wired, essentially. There is a painting called *La condition humaine* by Magritte in which a landscape painting is sitting in a windowsill on an easel, and outside the window is the same landscape you see in the easel painting. There is a sort of visual and conceptual mislement, which I love in that painting. There is a painting inside a painting inside a painting. Which is the real painting? Which is the real landscape? The human condition is to be caught in this conundrum of representation.

Campbell's Old Fashioned Vege-gene soup, 1996
Iris print on paper on can
4 x 2.5 x 2.5"

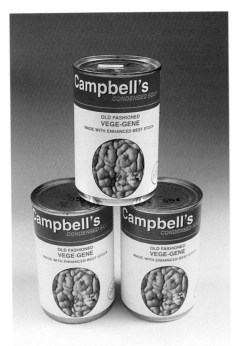

IB The insect sounds that fill the gallery when that piece is shown are very effective. How did you create the soundtrack?

AS I remember having a very difficult time with the soundtrack at first. For a few months I thought I may have to leave it silent, though I was not happy with that solution. At that time, I had been reading a good deal about insect life and behavior, and one day, while browsing the library files on insects, I came across a recording

of insect sounds. I loved it and I spent a long time tracking down the person who had recorded them (sound artist, David Dunn). He gave me permission to use and manipulate the sounds in any way I liked, which I did—emphasizing through repetition and pattern, in the editing process, certain sounds that seemed almost machine-like.

IB Insects inhabit your larger sculptures at this time also.

AS Around 1999 I began to make what I call the *Swarm* sculptures. The series combined plant and insect imagery creating a kind of crossbreed. The biggest white one, *Gregor Samsa's Other Dream* represents a kind of larval structure, dripping fluid, and at the same time being eaten by the fly-like creatures that made it, or are being born out of it. In these sculptures, I took a few familiar forms and conflated them—as bioengineering has conflated the borders between species. There are petal or wing shapes that mix flower and insect into one combined form, and the sculpture itself an overall shape that resembles a cell undergoing mitosis and maybe a dense swarm of some kind of bug around a food source. Finally, I used clear surgical tubing to connect all these elements, which for me suggests the way that nature has become something that needs our 'hospital' care and management—these genetic mutant wing/petal creatures are getting intravenous feeding.

Another important aspect to this body of work is that it is all hand-made. There are thousands of those petal/wings in the *Swarm* sculptures and each one was hand shaped, hand plasticized and hand wired onto the 'mother' structure. I suppose I would like the viewer to consider the meaning of a person sitting at home fabricating leaves for a homemade plant. Other materials in those works include Q-tips, floral tape, garbage bags, and thin wire— all household ingredients, or drug store materials creating a plant in a dream.

IB In *Mobile Flora*, you added simple plastic casters to the floor end of each of your fabricated stalks. This small detail speaks volumes

about what role these plants might be taking on. Is this a continuation of your interest in genetic engineering?

AS *Mobile Flora* is a sculpture that I see as having been engineered to be moveable for human convenience and self-feeding. It has wheels for easy transport, no roots, and tubes to feed itself and its neighboring plants. When this piece was shown at the Whitney, I removed the decorative potted plants that usually inhabit a rectangular hole in the floor of the lobby at the Phillip Morris office building, and filled the hole with white landscape gravel. I was thinking about the way in which we go about indoor landscaping, there is always an attempt at achieving a natural look; plants are brought in and out, they almost die, we replace them. The wheels allude to this process. We want to live with nature, but only if it's made safe and convenient.

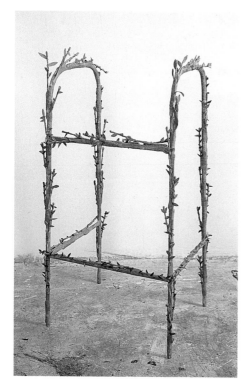

Nature Walker, 2001
Steel, rubber, tape, Q-tips
34 x 17 x 13"
Courtesy of the artist

IB Sometimes you actually build home-like interiors for these plants. Can you describe the setting for the work, *Indoor Gardening,* for instance?

AS For this work I built a sort of cut-away room—an example of cheap suburban architecture including fake wood paneling, linoleum tile, and electrical outlets. I chose this type of cheap and quick building style as an environment for the plants because it is evocative of the ubiquitous housing developments that are taking over land that was previously undeveloped, semi-wild, and in many cases providing valuable habitat for species of flora and fauna. I am trying to deal with that compromise we humans make wanting to live with nature, yet not wanting the inconvenient side of nature to get in the way—wanting convenience and wilderness at once. The myth of suburbia is

that nature and human habitation can coexist along with all those roads, electricity, running water, shopping malls etc. In some ways *Indoor Gardening* is a wishful vision of the plants having a kind of final triumph. Though they are modified to be wheeled around for corporate convenience, and in their modular design they can be arranged and rearranged in any configuration, in the end they penetrate the constructed walls around them—going through and into other spaces defying our desire to have nature contained and controlled.

IB Gardens have a long history of manipulated nature. How does the history of garden design fit within your thinking?

AS I actually made a sculpture for a garden in the Bronx at Wave Hill, the one-time home of both Mark Twain and Teddy Roosevelt. In fact, it is said to be the place where Roosevelt gained his appreciation for nature, which led him to create all of those wonderful National Parks later in life—it's now mainly a botanical garden and museum. I was very excited about the show at Wave Hill because of the garden context. The gallery setting creates a specific set of expectations and a garden creates a very different set. *Insectifera Vinealis* (which basically means hanging insect vine) was made to look like a strange plant growing without water or soil in one of their greenhouses. I concocted the name of this plant combing a few Latin names that describe the features of my sculpture, but it is not any known or specific plant—it is my own hybrid. In the same way, all of my plant sculptures are not replicas of any particular genus, they are about an idea or a memory of 'plantness.' My work is always nature remembered—I couldn't do it while looking out at nature—it's about how the parts get put together into memory in my mind—a human conception of nature. I study it, but then forget the specifics and get to work.

Garden design generally has not played a big part in my art, though the theory and meaning of gardens in different places in different centuries is very interesting to me. Apparently, gardens are recorded as having existed as early as 2500 BC in Egypt.

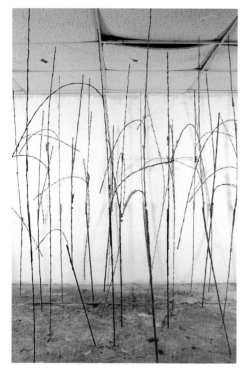

Field, 2000
Steel, latex, rubber, Q-tips, tape
Dimensions variable
Courtesy of the artist

(facing page)
Dense Field, 2003
Steel, latex, rubber, Q-tips, tape
Dimensions variable
Installation view, Tang
Museum, Skidmore College
Courtesy of the artist

Islamic gardens, are supposed to be represen-
tations of heavenly paradise on earth. In fact,
the word for paradise and garden in Arabic are
the same. The two main competing styles of
gardens: formal versus 'natural' are recorded
as early as 50 AD in Rome. In the west, we see
the development, in around the 17th century,
of French formal gardens such as those found
at Versailles. Those gardens were planned
and sculpted so that all pathways radiated
out and led back to the castle. Even shrubbery
was sculpted giving an impression that nature
itself was subject to the King. Subsequent to
those formal French gardens, English gardens
of the eighteenth century took the opposite
approach by finding inspiration in the arcadian
paintings of Poussin and Lorrian. In those
paintings nature looks 'natural' yet humanized.
In these wilder English gardens, there is no geo-
metrical sculpting, but instead paths meander
and juxtapositions of flora are made to appear
as though they had not been planted by man. The English, I believe,
were also the first to open public gardens. The idea of egalitarian
plant growth and egalitarian access was initiated due to a rising
class of landowners in England with anti French, anti baroque
values. Later some of these public gardens would include marble
monuments of notable figures that were intended to educate the
masses as they enjoyed the outdoors. What interests me in all this,
is the way nature is used by human consciousness as a vessel for
meaning. I think it is very difficult for us to see nature as a whole
or as itself. It is always filtered through our various fears, desires,
political ambitions etc.

IB You are also making digital prints that begin as something close
to collage and end up in a new space filled with duplicated scanned
imagery and new forms created on the computer. How do these

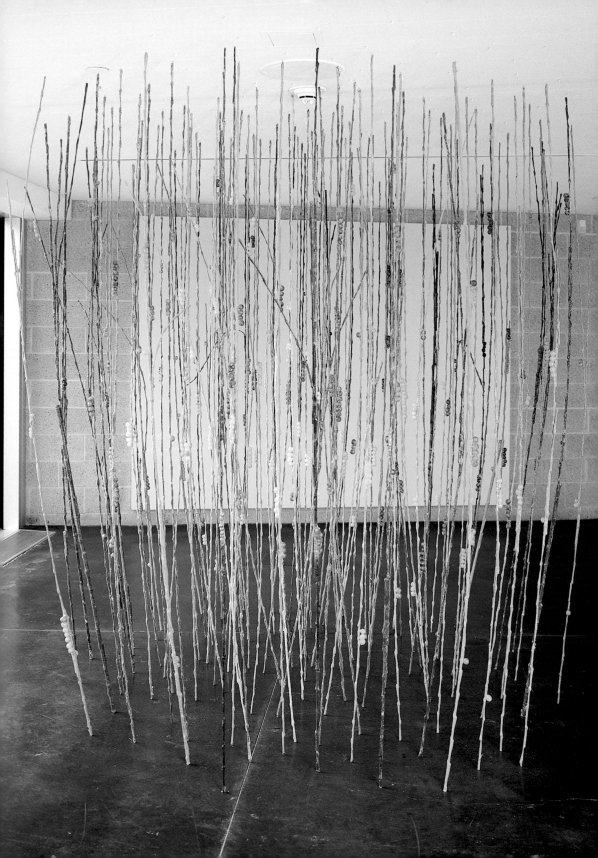

relate to your earlier photographic works, and what are some of the sources you are looking to now?

AS In the series of digital photographs titled *False Branches*, I used the computer to create imaginary natural structures using my own photographs and sculpture as source material. This series is similar to the *Details* piece we discussed earlier, except that its construction is much more complex. In many ways, these digital photographs are related to everything from science fiction films to Max Ernst collages. The images depict natural looking worlds that seem to be both macroscopic and microscopic at the same time. I was looking at microscopic structures like Radiolaria, which are frothy microscopic life forms that sport silica skeletons, as well as Hubbell telescope photos of celestial phenomena. Like other works of mine these configurations appear to be simultaneously natural and artificial, and are intended to impel the viewer to confront his or her preconceptions about notions of organic versus artificial creation.

During the making of this body of work, I was also thinking alot about a passage in the Bruno Schulz book *Street of Crocodiles*, in which he describes what happens when the main character opens a long forgotten door in his house. It seems that over time, in that abandoned room, shimmering crystalline plant like forms have sprouted from floor to ceiling. The narrator gets a short glimpse of this fragile beauty before it crashes to the ground shattering with the vibration caused by the opening of the door. My structures are also impossible structures—dream plants of the imagination.

IB Your most recent sculpture is an outdoor work entitled *Mirror Fence*. The piece is a 140-foot long standard sized picket fence that has been faced with Plexiglas mirror. We discussed reflection as an ongoing subject of your work earlier, what are you intending to reflect with this work?

AS *Mirror Fence* came out of my thoughts about the concept of suburbia in the United States. When I think of American suburbia

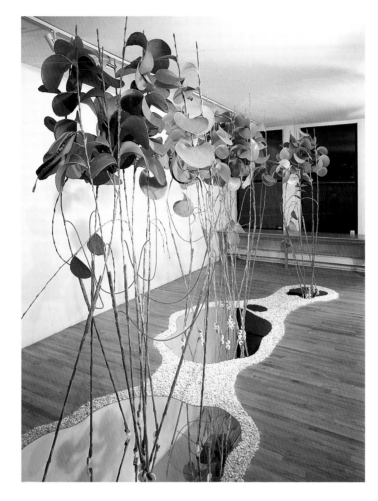

Still Life, 2001
Rubber, latex, steel, tape,
Q-tips, casters, mirror, gravel
108 x 42 x 216"
Installation view, Susan Inglett,
New York

the very first thing I think of is "the American dream"—a house
with a yard surrounded by a white picket fence. This image sym-
bolizes, for Americans, the potential we are all supposed to have
to be upwardly mobile. My mirrored fence is a statement about
that dream: the way in which it physically flickers in and out of
perception like a digital effect or trick of technology reflects the
way in which this dream is something always a little out of reach.
It is a dream we are trained to chase after and desire. The purpose
of a real white picket fence is to create 'pretty' boundaries around
property. It says 'I own this land,' but it says it in a neighborly
way. It is not a chain link fence that says 'get out.' It says 'I'll stay
on my side if you stay on your side.' The mirror fence turns that

polite relationship inside out by reflecting those inside and those outside simultaneously. The two parties are distorted visually, and brought together somewhat by the breaking up of space between the pickets, and conceptually by the relationship of property and ownership.

IB You first made the fence for a summer show at Socrates Sculpture Park in Brooklyn and now have re-fabricated the work for long term display outside the museum at Skidmore. Does the change in site change the work for you? Also, how do you imagine it will change as the seasons change?

AS I think all artwork changes it's meaning somewhat when it changes it's setting. However, with *Mirror Fence* the effect is probably amplified because it's essence, really, is created by the reflections of the specific place it's installed. Also, at Socrates it was in an exhibition with other outdoor sculpture. At the Tang it will be a much more unexpected object. I like the idea that students will find it there and wonder about it and maybe be a bit mystified by it. I also hope that there will be dramatic differences in the character of the piece in different seasons. It seems like winter could be very interesting, with snow making it almost entirely invisible.

IB Your new work returns to the process of collage to make very colorful and increasingly large scale "paintings." Can you talk a bit about how the process relates to your early works?

AS Since my first one person show in 1995, I have continued to make drawings in a similar vein to 'outside inside inside out'. The drawings now are still based on parts found in nature, but they are becoming much more abstracted and even inspired by manipulations I make to them in the computer. In these new paintings I am working on, I have developed a technique whereby I collage parts of the drawings onto panel and then paint into them with oil paint in between layers of resin. Usually five or six coats are

applied, creating depth through transparency, translucence, and shadow. In some of the paintings, digitally manipulated photos of nature and my own sculpture are collaged in as well. The result is a painting that has physical depth; one can look into them—like looking into a pond. In this way they side step traditional painting creating a hybrid of sorts between drawing, painting, sculpture and photography.

IB You are making these works alongside new sculptures. Is it the same process? Since you are about to unveil some new works— where do you think they might be headed?

AS The newest works are becoming more layered and less dense. In a strange way, the evolution of the imagery in these has been like a dense implosion that is now drifting outwards—similar to the big bang. I don't know where they will end up, but I am continuing to make sculpture as well as the paintings. The two mediums are quite com-plimentary in that they energize one another. When I don't know where to go in one, I work on the other and usually come back with some sort of answer. Some of the spatial things I am attempting in my sculp-ture become clear in the paintings and vice versa. For me, in any case, these distinctions between different media are false boundaries that I delight in tearing down.

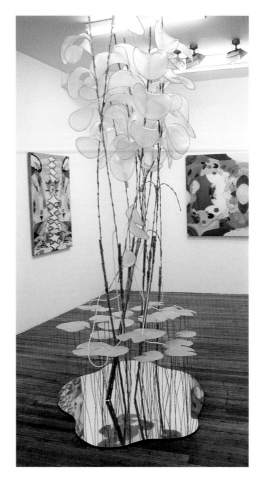

Still Life in Frozen Time, 2003
Rubber, resin, wood, steel, tubing,
Q-tips, tape, bees wax,
Epoxy, and mirror
108 x 65 x 45"
Installation view, Derek Eller Gallery, New York

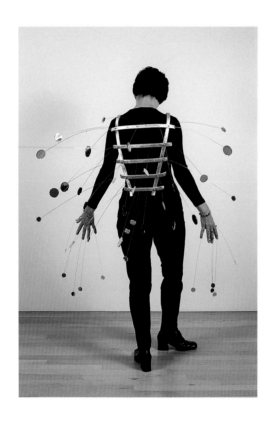
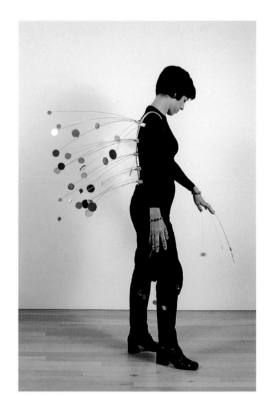

Reflective Extensions, 1997
Steel, steel wire, cut mirrors
Hand pieces, each 2 x 3 x 20"
Collection of Tony Zunino
Back piece, 35 x 32 x 23"
Collection of the artist

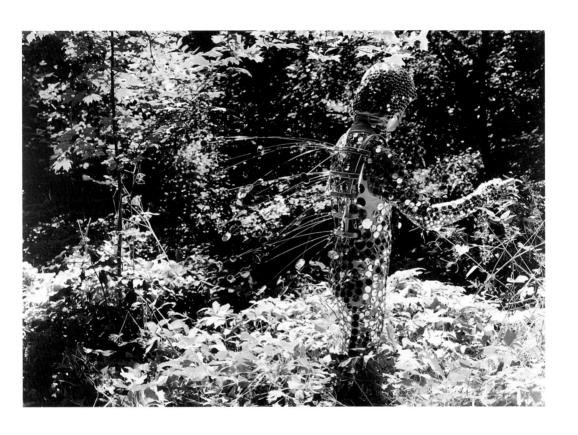

Untitled (Reflective Mimicry), 1997
C-print
24 x 36"
Courtesy of the artist

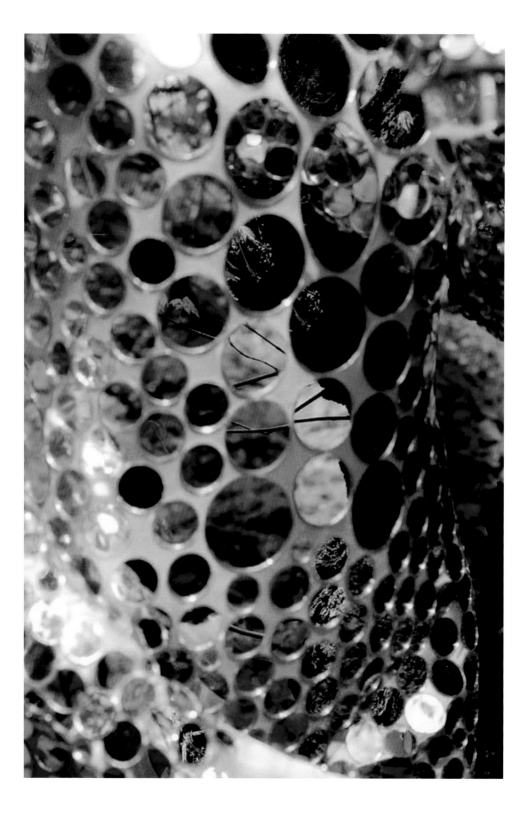

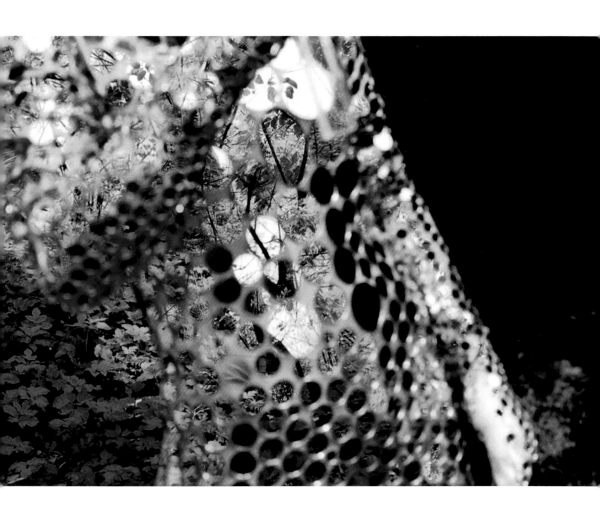

Prints from the series
Untitled (Reflective Mimicry), 1997
C-print
24 x 36"
Courtesy of the artist

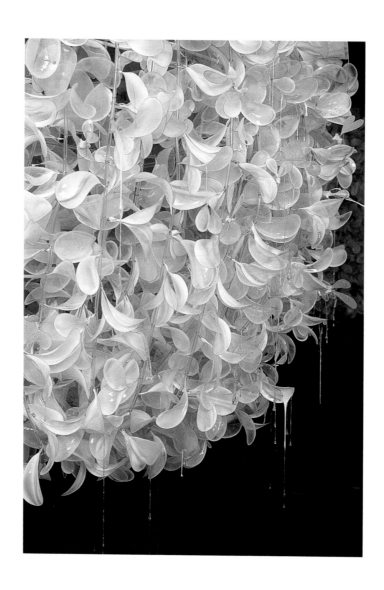

(facing page, detail above)
Gregor Samsa's Other Dream, 1999
Form-a-film, wire, surgical tubing
70 x 50 x 50"
West Family Collection

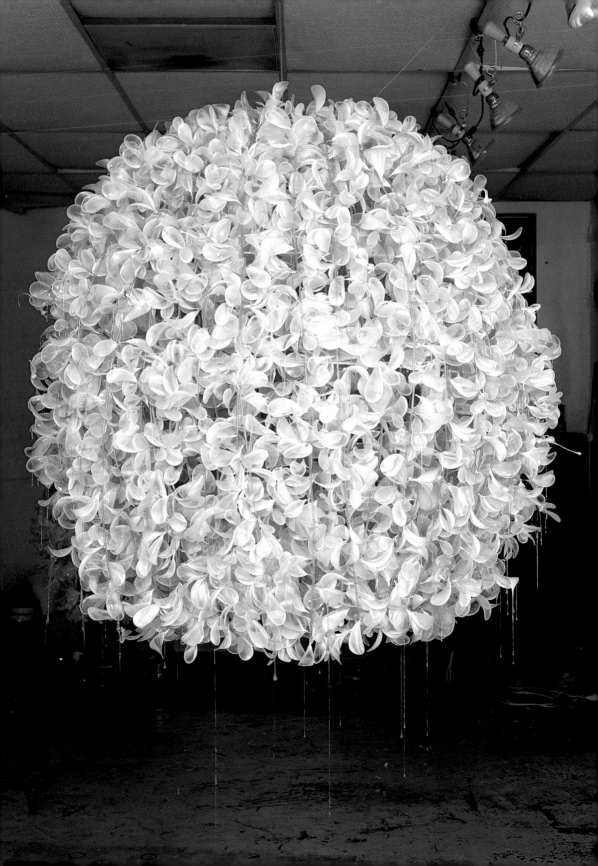

Untitled, 2000
Pencil on paper
Four drawings, each 10.5 x 7.5"
Collection of the artist

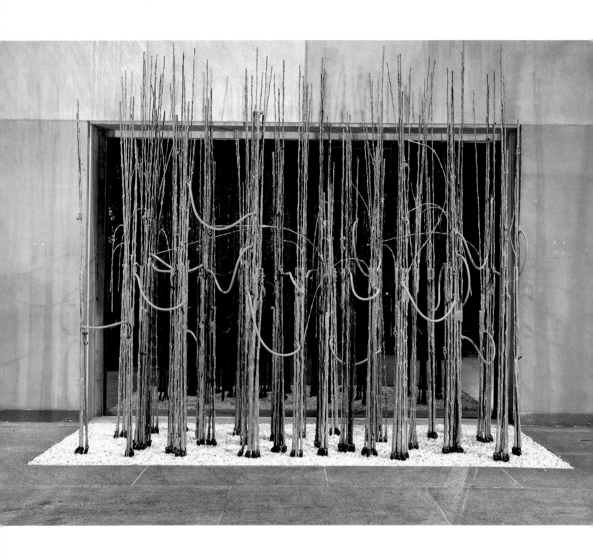

(above, detail on right)
Mobile Flora, 2000
Steel rods, wood, Q-tips, floral tape,
latex rubber, casters, electrical and
plumbing parts, rubber tubing,
marble chips
108 x 144 x 72"
Collection of Eileen and Peter Norton,
Santa Monica
Installation views, *Pastoral Pop!*,
Whitney Museum of American Art
at Philip Morris, New York

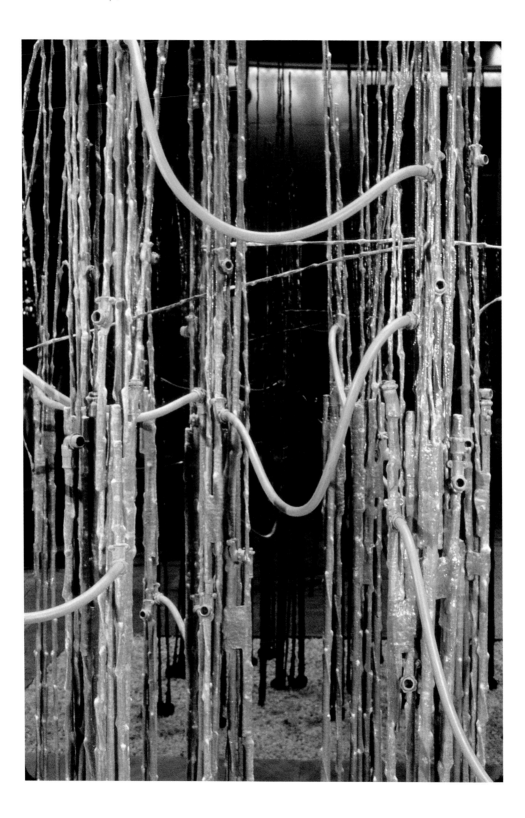

Natural Selection #5, 1999
Iris print on paper
20 x 24"
Published by Muse X Editions,
Los Angeles

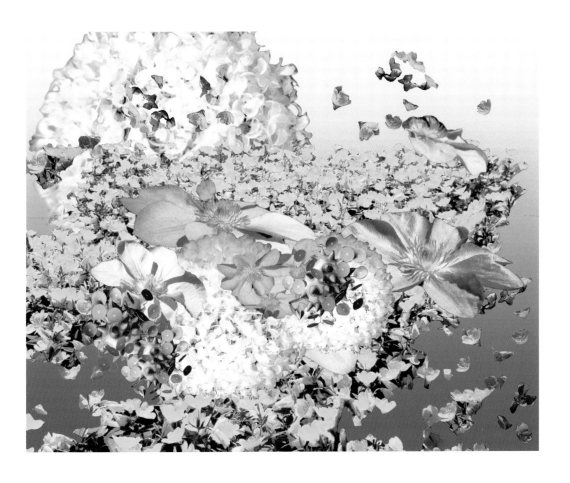

Natural Selection #3, 1999
Iris print on paper
20 x 24"
Published by Muse X Editions,
Los Angeles

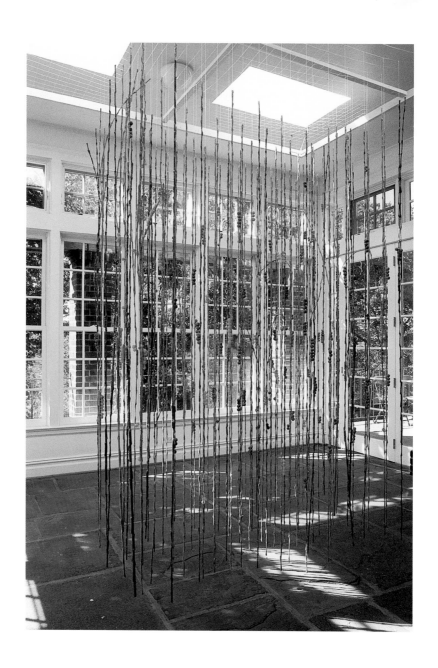

(above, detail on right)
Insectifera Vinealis, var. Pendula, 2001
Rubber, tape, steel, trellis, Q-tips
240 x 64 x 18"
Installation views, *Sensing the Forest*,
Wave Hill, Bronx, New York

32

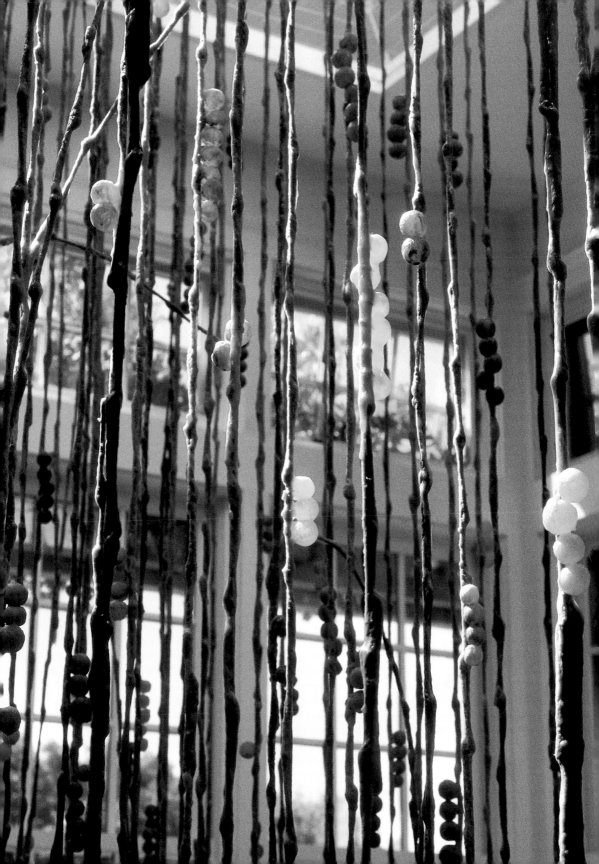

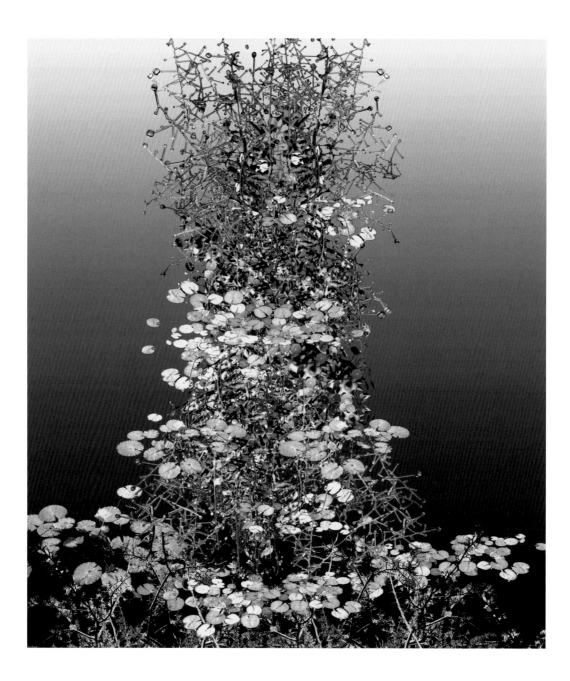

False Branches #6, 2001
Lambda print on Fujiflex
50 x 50"
Courtesy of the artist and
Mixed Greens, New York

34

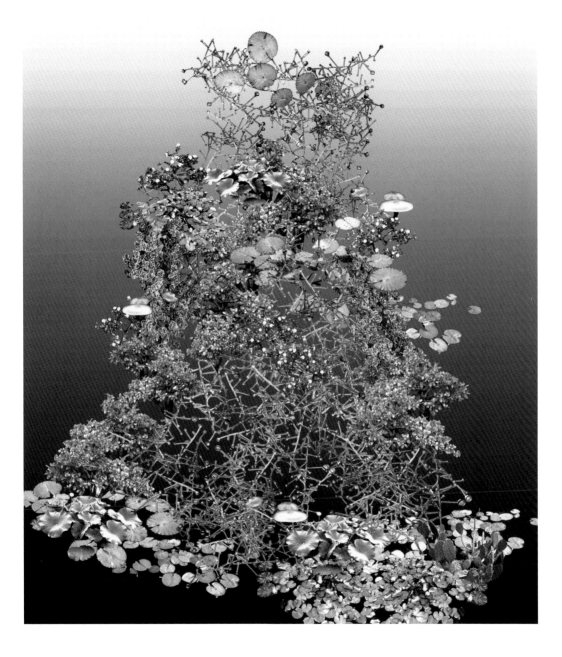

False Branches #9, 2002
Lambda print on Fujiflex
50 x 50"
Courtesy of the artist and
Mixed Greens, New York

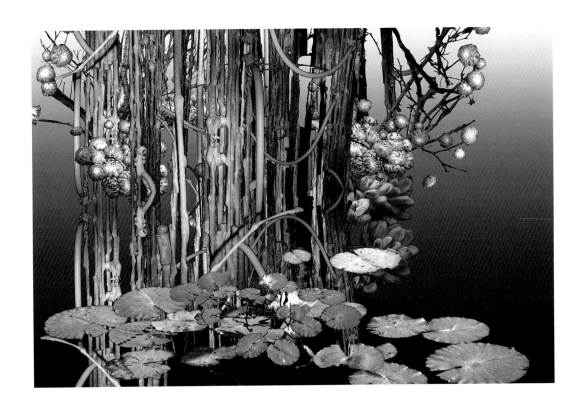

False Branches #1, 2002
Lambda print on Fujiflex
19 x 28"
Courtesy of the artist and
Mixed Greens, New York

(facing page)
Indoor Gardening, 2002
Rubber, steel, wood, casters,
tubing, tape, q-tips, fake wood panel,
sheetrock, linoleum tile, outlets
105 x 174 x 120"
Installation view, Lemon Sky
Projects, Los Angeles

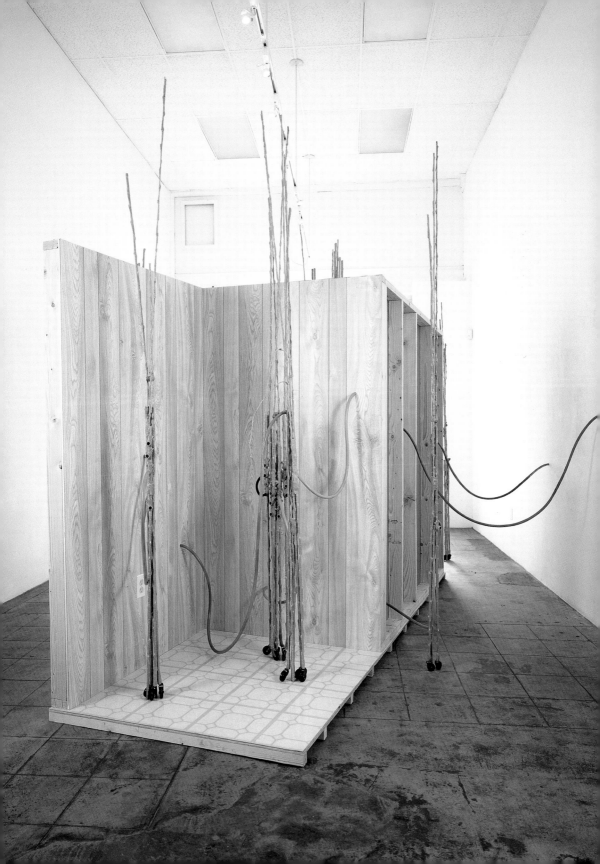

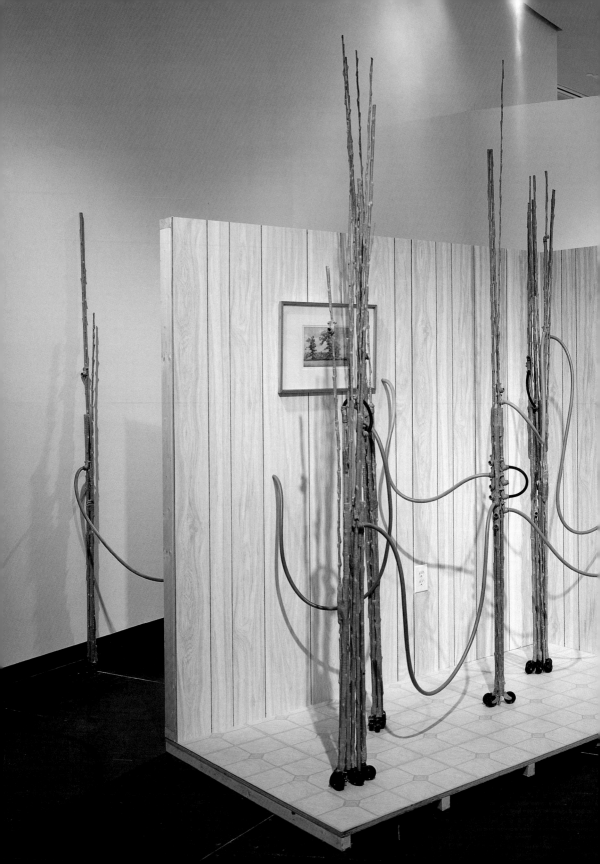

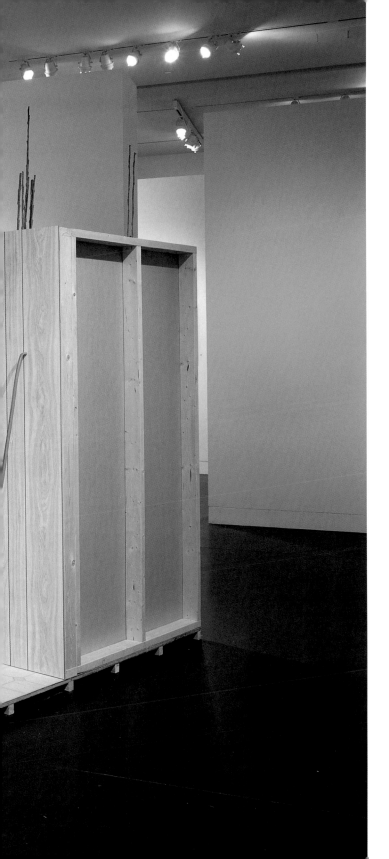

Indoor Gardening, 2002
Rubber, steel, wood, casters,
tubing, tape, Q-tips, fake wood
panel, sheetrock, linoleum
tile, outlets
105 x 174 x 120"
Installation view, Tang Museum,
Skidmore College

Double Oasis, 2002
Oil, gouache, ink, resin,
and collage on panel
48 x 36"
Courtesy of the artist and
Derek Eller Gallery, New York

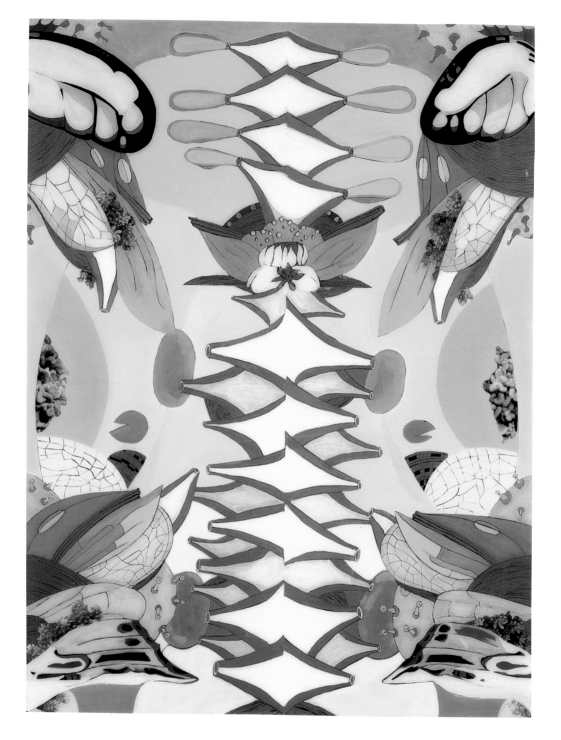

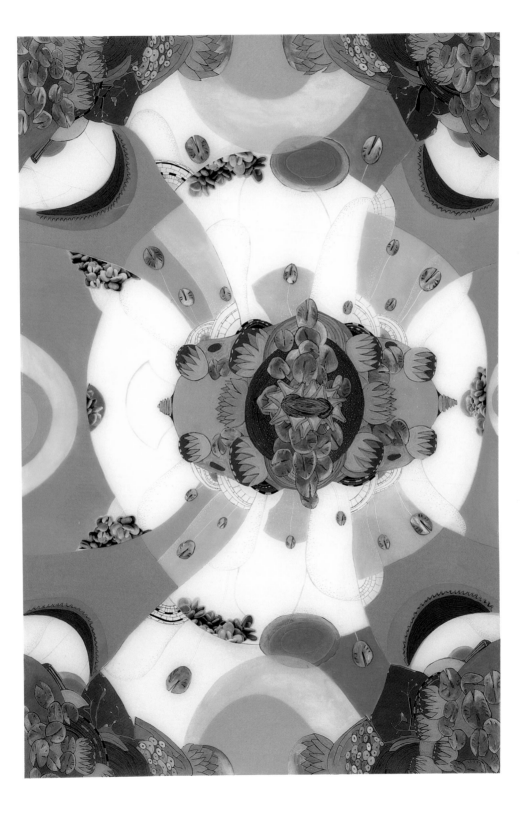

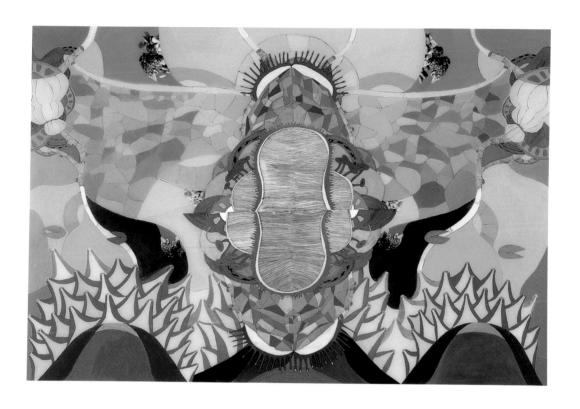

(facing page)
Trans Ocular, 2002
Oil, gouache, ink, resin,
and collage on panel
72 x 48"
West Family Collection

Western Paradise, 2003
Oil, gouache, ink, resin,
and collage on panel
48 x 72"
Courtesy of the artist and
Derek Eller Gallery, New York

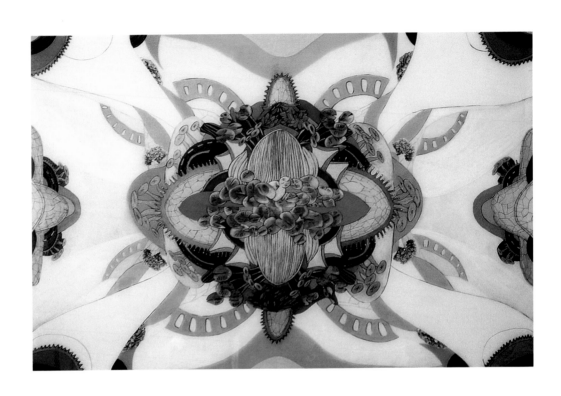

Landscape Shift, 2003
Oil, gouache, ink, resin,
and collage on panel
48 x 72"
Collection of Carolina Nitsch
and Dieter von Graffenried

(facing page)
Still Life in Frozen Time, 2003
Rubber, resin, wood, steel,
tubing, Q-tips, tape, beeswax, epoxy, mirror
108 x 65 x 45"
Installation view, Tang Museum,
Skidmore College

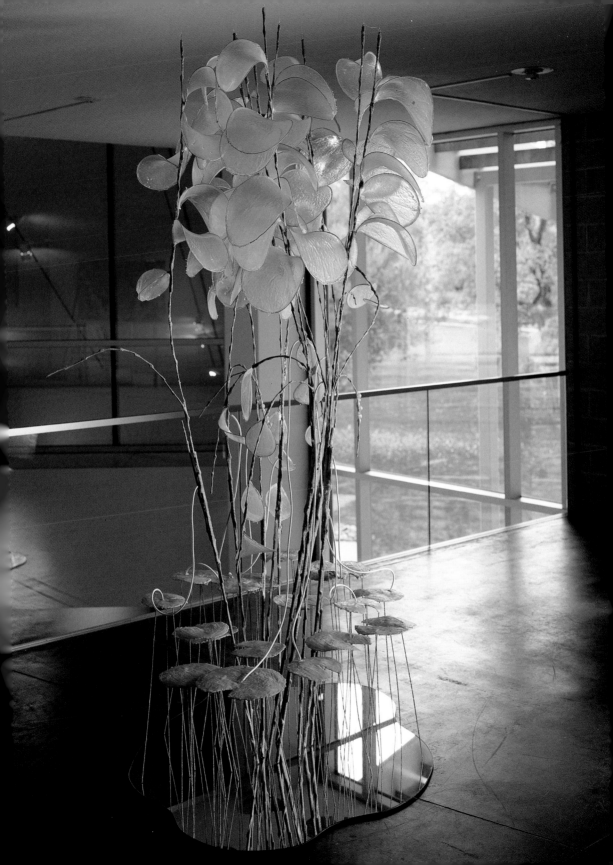

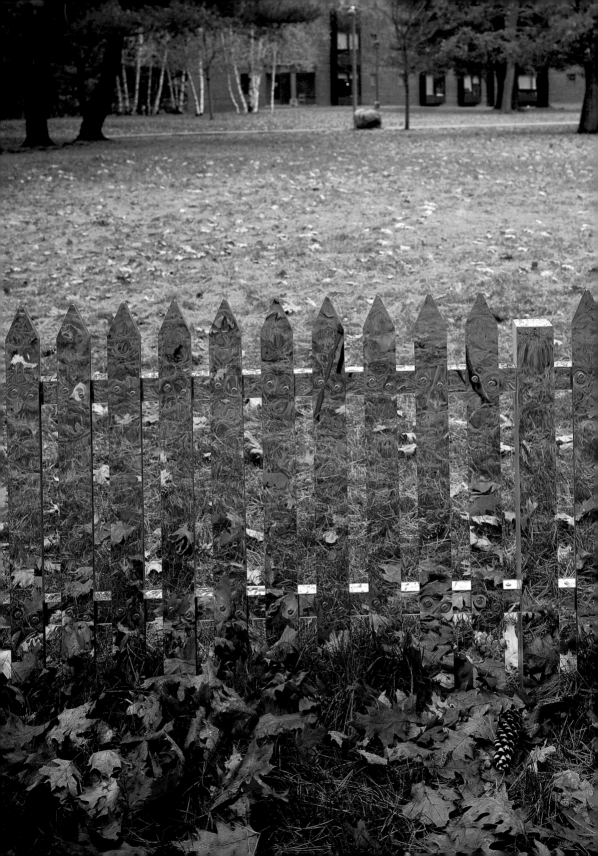

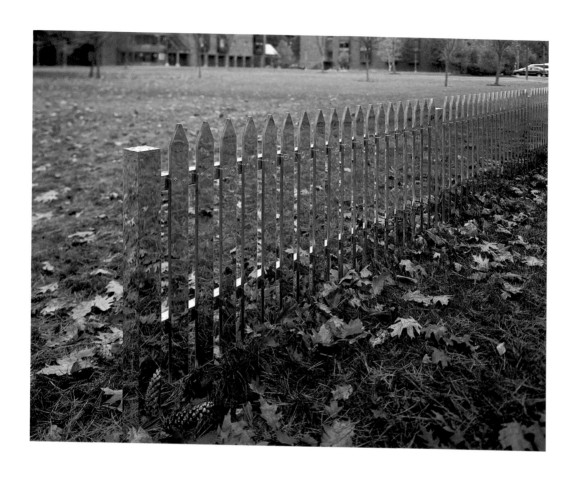

Mirror Fence, 2003
Acrylic, wood, aluminum, hardware
138' x 36 x 4"
Installation views, Tang Museum,
Skidmore College

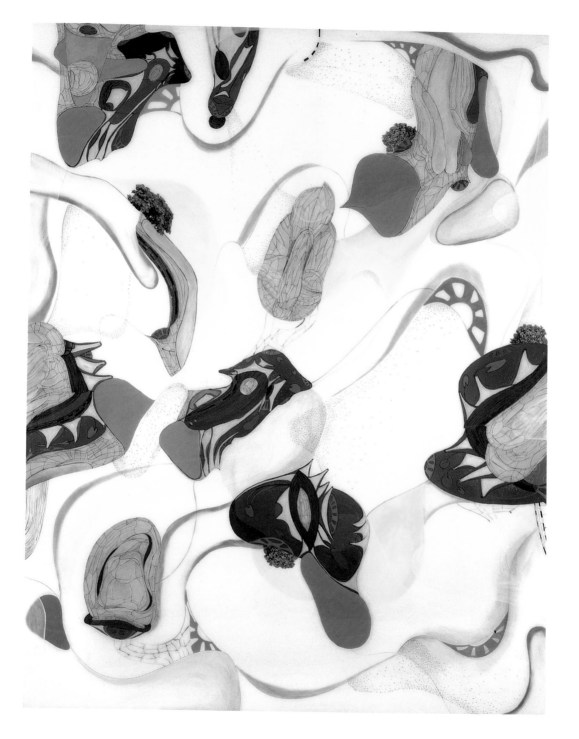

Organic Bloom, 2003
Oil, gouache, ink, resin,
and collage on panel
92 x 72"
Courtesy of the artist

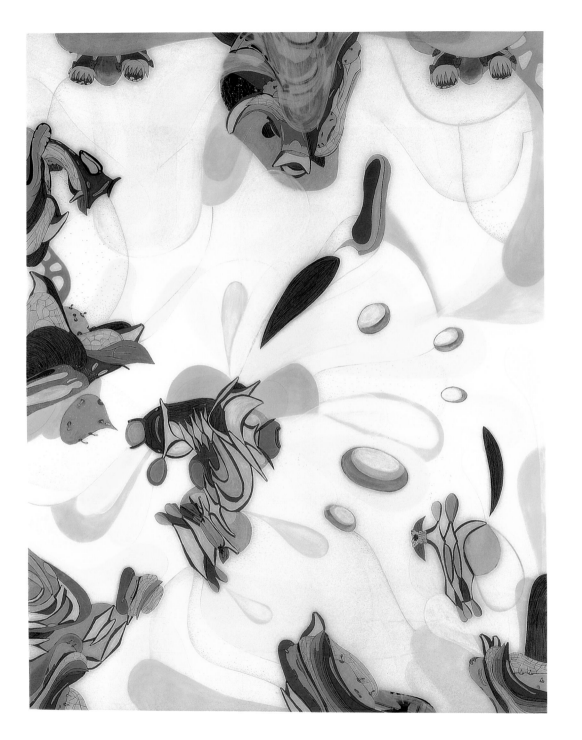

CHECKLIST

*All works by Alyson Shotz and courtesy
of the artist except where noted;
all dimensions in inches, h x w x d*

Untitled, 1997
Painted wood, cut mirrors
11 x 22 x 13"

Swarm, 1998
Form-a-film, surgical tubing,
garbage bags, steel wire
108 x 36 x 36"

Light Itself, 1998
Sculpey, wire, cut mirrors
Dimensions variable

Centers of Creation, 1999
animation
60 minutes

Untitled, 2000
Pencil on paper
Twelve drawings, each 10.5 x 7.5"

False Branches #6, 2001
Lambda print on Fujiflex
50 x 50"
Courtesy of the artist and Mixed Greens,
New York

False Branches #9, 2002
Lambda print on Fujiflex
50 x 50"
Courtesy of the artist and Mixed Greens,
New York

Indoor Gardening, 2002
Rubber, steel, wood, casters, tubing, tape,
Q-tips, fake wood panel, sheetrock, linoleum
tile, outlets
105 x 174 x 120"

Branching Study, 2002
Flame worked pyrex glass rod
12 x 20 x 12"

Western Paradise, 2002
Oil, gouache, ink, resin, and collage
on panel
48 x 72"
Courtesy of the artist and
Derek Eller Gallery, New York

A Slight Magnification, 2002
Oil, gouache, ink, resin, and collage
on panel
48 x 72"
Courtesy of the artist and
Derek Eller Gallery, New York

Still Life in Frozen Time, 2003
Rubber, resin, wood, steel, tubing,
Q-tips, tape, bees wax,
Epoxy, and mirror
108 x 65 x 45"
Courtesy of the artist and
Derek Eller Gallery, New York

Mirror Fence, 2003
Acrylic, wood, aluminum, hardware
138' x 36 x 4"

Organic Bloom, 2003
Oil, gouache, ink, resin, and
collage on panel
92 x 72"

Snow Melt, 2003
Oil, gouache, ink, resin, and
collage on panel
92 x 72"

Dense Field, 2003
Steel, latex, rubber, Q-tips, tape
Dimensions variable

(below)
Untitled, 1997
Painted wood, cut mirrors
11 x 22 x 13"

(opposite)
Light Itself, 1998
Sculpey, wire, cut mirrors
deimensions variable
Installation view, Tang
Museum, Skidmore College

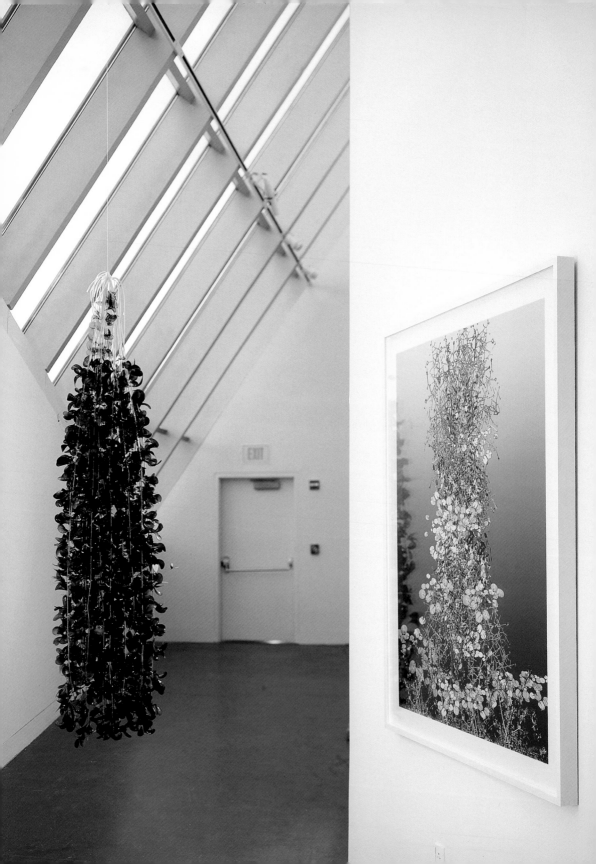

ALYSON SHOTZ

Born in Glendale, Arizona in 1964
Lives and works in New York, New York

Education

1991
M.F.A., University of Washington, Seattle, Washington

1987
B.F.A., Rhode Island School of Design, Providence, Rhode Island

Selected Solo Exhibitions
(Exhibitions are followed by dates where available.
 Traveling exhibitions are listed under their initial
 date and venue)

2003
A Slight Magnification of Altered Things, The Tang Teaching Museum
 and Art Gallery, Skidmore College, Saratoga Springs, New York,
 October 18–December 31
Paradise, Derek Eller Gallery, New York, New York, April 22–May 24

2002
Indoor Gardening, Lemon Sky Projects, Los Angeles, California,
 November 23–December 21

1999
Alyson Shotz, Susan Inglett Gallery, New York, New York,
 September 17–October 23
Marvels of the Universe, Susquehanna Art Museum, Harrisburg,
 Pennsylvania, June 1–August 21

1998
Alyson Shotz, Susan Inglett Gallery, New York, New York,
 January 9–February 14

1997
Lemon Sky Projects, Los Angeles, California

1996
Drawings, Susan Inglett Gallery, New York, New York, April 5–May 18

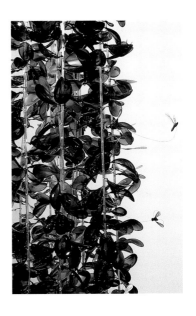

(facing page, on left, and
detail above)
Swarm, 1998
Form-a-film, surgical tubing,
garbage bags, steel wire
108 x 36 x 36"
(facing page, on right)
False Branches #6, 2001
Lambda print on Fujiflex
50 x 50"
Installation view, Tang Museum,
Skidmore College

Selected Group Exhibitions

2003

Strange Worlds, Bertha and Karl Leubsdorf Gallery, Hunter College, New York,
 New York, October 30–December 13

Larger Than Life: Women Artists Making It Big, Susquehanna Art Museum,
 Harrisburg, Pennsylvania, June 12–August 29

*Yard: An Exhibition about the Private Landscape that Surrounds Domestic
 Architecture,* Socrates Sculpture Park, Queens, New York, May 11–August 3

bits 'n' pieces, D.U.M.B.O. Arts Center Gallery, Brooklyn, New York,
 February 8–March 30

UnNaturally, Independent Curators International Touring Exhibition:
 University of South Florida Contemporary Art Museum, Tampa, Florida,
 January 18–March 15, 2003; F. Donald Kenney Museum, Regina A. Quick
 Center for the Arts at St. Bonaventure University, St. Bonaventure,
 New York, February 3–March 30; Fisher Gallery, University of Southern
 California, Los Angeles, California, November 19, 2003–January 17, 2004;
 The American Center for Wine, Food, and the Arts, Napa, California, April
 30–August 16, 2004; Lowe Art Museum, University of Miami, Coral Gables,
 Florida, September 16–November 14, 2004

2002

Fictions in Wonderland, Reynolds Gallery, Richmond, Virginia,
 October 18–December 14

(on floor)
Joseph Grigeley and Alyson
Shotz, *E-Z Gene Splicer Kit
and Recombination Kit,* 1994
Mixed media

(on wall)
Alyson Shotz, *Untitled,* 1994
Silver gelatin prints

Installation view, *The Natural
World,* A/C Project Room,
New York, 1994

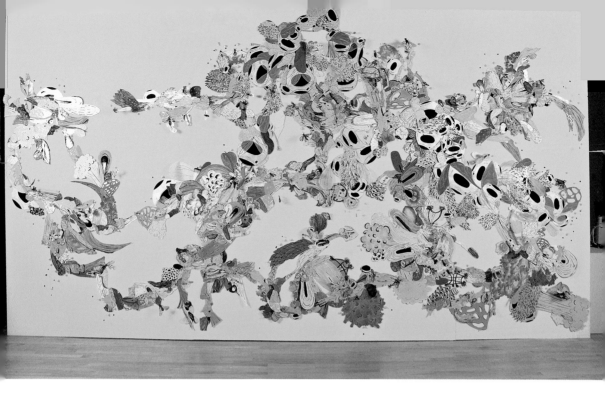

Mirror Mirror, Massachusetts Museum of Contemporary Art, North Adams,
 Massachusetts, October 5, 2002–January 5, 2003
Into the Woods, Julie Saul Gallery, New York, New York, June 28–August 16
Dangerous Beauty, Jewish Community Center in Manhattan, New York,
 New York, May 24–September 8

2001

Sensing the Forest, Glyndor Gallery, Wave Hill, Bronx, New York, September
 16–November 25
Let's Get to Work, Susquehanna Art Museum, Harrisburg, Pennsylvania,
 July 21–October 20
Being There, Derek Eller Gallery, New York, New York, June 28–July 27
Digital Printmaking Now, Brooklyn Museum of Art, Brooklyn, New York,
 June 22–September 2
Mixed Greens at Space 101, Brooklyn, New York, April 28–May 20
Material Whirled, Art in General, New York, New York, April 21–June 30
Plant Life, KS Art, New York, New York

Untitled, 2000
Gouache and ink on paper
with wire, sculpey, and false
eyelashes
9 x 30'
Installation view, *Blurry Lines*,
John Michael Kohler Arts
Center, Sheboygan, Wisconsin

2000

Snapshot, Contemporary Museum, Baltimore, Maryland,
 November 2–January 14, 2001

Muse-X Editions, Barbara Krakow Gallery, Boston, Massachusetts,
 October 21–November 29

Wildlife, Reynolds Gallery, Richmond, Virginia, October 13–November 11

Blurry Lines, John Michael Kohler Arts Center, Sheboygan, Wisconsin,
 October 8–January 14, 2001

The Living End, Boulder Museum of Contemporary Art, Boulder, Colorado,
 September 15–December 23

Pastoral Pop, The Whitney Museum at Phillip Morris, New York, New York,
 July 21–December 15

Not a Theme Show, Pittsburgh Center for the Arts, Pittsburgh, Pennsylvania,
 February 19–April 16

Greater New York: New Art in New York Now, P.S.1 Contemporary Art Center,
 Queens, New York, February 7–May 14

Showroom, The Arts Center of the Capital Region, Troy, New York,
 January 29–April 8

Photasm, Mandeville Gallery at the Nott Memorial, Union College,
 Schenectady, New York

1999

Coming Off The Wall, Susquehanna Art Museum, Harrisburg, Pennsylvania,
 November 18–February 26

Best of the Season, Aldrich Contemporary Art Museum, Ridgefield,
 Connecticut, September 26–January 9, 2000

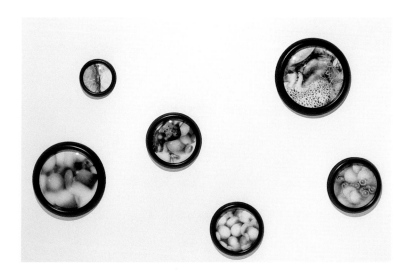

Untitled (22 details), 1995
(detail)
Photographs in frames
Dimensions variable

Nature is Not Romantic, Bertha and Karl Leubsdorf
Art Gallery, Hunter College,
New York, New York, March 30–May 15
Sound Foundations: Audio in Video, Center for
Curatorial Studies, Bard College, Annandale-on-
Hudson, New York , March 14–28
Comfort, Post Gallery, Los Angeles, California,
January 9–February 6
Zingmagazine Curatorial Video Crossing,
Sudhausarbar/Warteck PP, Basel, Switzerland

1998

Pop-Surrealism, The Aldrich Museum of
Contemporary Art, Ridgefield, Connecticut,
June 7–August 30
Video Library, David Zwirner Gallery, New York,
New York, March 18–April 18
New Video from The Outpost, The Kitchen,
New York, New York

1997

Art on Paper, Weatherspoon Art Museum,
University of North Carolina, Greensboro, North
Carolina, November 16–January 18, 1998
Dead-Fit Beauty, Bertha and Karl Leubsdorf Art
Gallery, Hunter College, New York, New York,
February 4–March 9

1996

Anxious Times, Department of Visual Arts, Weber State University, Ogden,
Utah, January 2–31
Giftland V: Democrasy, Printed Matter, New York, New York Nov. 29–Dec. 23
Alem de Agua: Copiacabana, El Museo Extremeño e Iberoamericano de Arte
Contemporáneo, Badajoz, Spain

1995

August 28, organized by Domestic Setting at Rio Hondo College, Whittier,
California, August 28–September 21
Fools Day, 12 Warren, New York, New York

1994

The Natural World, AC Project Room, New York, New York

Untitled, 2001 (detail)
Rubber, steel, casters, tubing,
wood panel, outlet
108 x 74 x 53"

Bibliography

Selected Catalogues and Brochures

Adler, Tracy and Heidi Zuckerman. *Nature is Not Romantic*. Exhibition catalogue. New York, New York: Hunter College, 1999.

Berry, Ian. *Showroom*. Exhibition catalogue. Troy, New York: The Arts Center of the Capital Region, 2000.

Cappellazzo, Amy. *On Paper*. Exhibition catalogue. Greensboro: University of North Carolina, Weatherspoon Art Gallery, 1997.

Klein, Richard, Ingrid Schaffner, and Dominique Nahas. *Pop Surrealism*. Exhibition catalogue. Ridgefield, Connecticut: The Aldrich Museum of Contemporary Art, 1998.

Lobdell, Laura. *Material Whirled*. Exhibition brochure. New York: Art in General, 2001. Essay by Susan Harris.

Lombino, Mary-Kay. *UnNaturally*. Exhibition catalogue. New York: Independent Curators International, 2003. Essay by Philip K. Dick.

McGregor, Jennifer. *Sensing the Forest*. Exhibition brochure. Bronx, New York: Wave Hill, 2001.

Singer, Debra. *Pastoral Pop!* Exhibition brochure. New York, New York: Whitney Museum of American Art at Philip Morris, 2000.

Slome, Manon. *Dangerous Beauty*. Exhibition catalogue. Jewish Community Center, New York, 2002

Van Dyke, Jonathan. *Coming Off the Wall*. Exhibition catalogue. Harrisburg, Pennsylvania: Susquehanna Art Museum, 1999

VanDyke, Jonathan. *Marvels of the Universe*. Exhibition brochure. Harrisburg, Pennsylvania: Susquehanna Art Museum, 1999

Selected Articles and Reviews

Bennet, Lennie. "Fooling Around with Mother Nature." *St. Petersburg Times* (26 January 2003)

Boyce, Roger. "Neither Here nor There: Mirror Mirror at Mass MoCA." Review. *Art New England*, v.24 no. 2 (February 2003): 16–17, 74.

Budick, Ariella. "Shifting Landscapes." *Newsday* (20 August 2000).

Clifford, Katie. "Alyson Shotz: Susan Inglett." Review. *The New Art Examiner*, no. 5 (February 2000): 53.

Cotter, Holland. "Mixed Greens at Space 101." Review. *The New York Times* (18 May 2001): E29.

Cotter, Holland. "Art in Review: Dead-Fit Beauty." Review. *The New York Times* (28 February 1997): C32.

Cullen, Sandy. "Artist Finds Change Lies Hidden in the Details." *Harrisburg Patriot-News* (17 January 1999).

Dawson, Jessica. "Edgy Art in Richmond." *Washington Post* (26 December 2002): C1.

Fujimori, Manami. "Graceful Touch in High Tech Age." *BT Magazine* (July 1996): 113.

Goodman, Jonathan. "Pastoral Pop." *Contemporary Visual Arts*, no. 31 (Fall 2000).

Hirsch, Faye. "Gene-Seeds." *On Paper* (September/October 1996): 30–31.

Hirsch, Faye. "Reflective Mimicry." *On Paper* (March/April 1998): 41.

Johnson, Ken. "Pastoral Pop." *The New York Times* (11 July 2000): E34.

Johnson, Ken. "Art in Review." *The New York Times* (8 October 1999): E37.

Kino, Carol. "Surveying the Scene II: The Emergent Factor." *Art in America*, no. 7 (July 2000,): 44–49.

Krajewski, Sara. "Blurry Lines: John Michael Kohler Center for the Arts." *New Art Examiner*, no. 6 (March 2001): 47.

Laird, Tessa. "Los Angeles." *Art on Paper*, no. 5 (March 2003): 74–75.

Levin, Kim. "Voice Choice." *The Village Voice* (5 October 1999): 140

Levin, Kim. "Voice Choice: The Natural World." *The Village Voice* (August 16 1994): 65.

Nagy, Peter. "Against Nature." *Time Out New York*, no. 257 (24 August 2000): 52.

Nahas, Dominique. "Dead-Fit Beauty." *Review* (15 February 1997): 30.

Naves, Mario. "It's Not Nice to Fake Mother Nature." *The New York Observer* (28 August 2000).

Ollman, Leah. "Pseudo Nature is Hip but Sterile." *Los Angeles Times* (13 December 2002).

Parker, Lauren. "Knock Knock." *Smock Magazine*, #3 (Spring/Summer 2001): 107.

Pratt, Kevin. "Yard." *Artforum*, (13 September 2003): 229.

Proctor, Roy. "Modern Nature." *Richmond Times Dispatch* (12 November 2000): H2.

Proctor, Roy. "Pacesetting Space." *Richmond Times Dispatch* (27 October 2002): H1.

Rothbart, Daniel. "A Walk in the Woods." *NY Arts* (September 2001): 22–23.

Schmerler, Sarah. "Reviews." *Time Out New York*, no. 213(21 October 1999): 74.

Schwendener, Martha. "Alyson Shotz at Susan Inglett." Review. *Art in America* (December 1996): 104.

Scott, Andrea. "Galleries Chelsea: Alyson Shotz at Derek Eller." *The New Yorker* (12 May 2003).

Smith, Roberta. "Art in Review." *The New York Times* (26 April 1996): C27.

Smith, Roberta. "Art Rediscovers a Home on the Upper East Side." Review. *The New York Times* (30 May 1999): E31.

Smith, Roberta. "Impressions of the Yard, Visual and Olfactory." Review. *The New York Times* (27 June 2003): E28.

Spaid, Sue. "L.A. Undercover: A Profile of Alternative Projects." *Art Papers*, no. 2 (March/April 1998): 14–17.

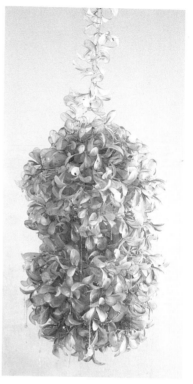

Pink Swarm, 1999
Form-a-film, steel wire,
surgical tubing, Paraloid
50 x 24 x 24"
Collection of Lee and
Kelly Stoetzel

ACKNOWLEDGEMENTS

For the past ten years Alyson Shotz has created a great variety of artwork with an inventive list of media that has remained focused on the investigation of nature in its real and fantasy guises. Her exciting body of work has succeeded in all of its incarnations and fits perfectly into the Tang Museum's series of exhibitions that feature new artists and artwork. *A Slight Magnification of Altered Things* includes a long-term outdoor sculpture, video, new paintings, and installations that inspire our students and visitors to find their place in the many conversations about the natural world. Alyson's project is the fifth in the Opener series at the Tang, which is generously funded by The Laurie Tisch Sussman Foundation, The New York State Council on the Arts, The Overbrook Foundation, and the Friends of the Tang.

Thanks to Susan Inglett for introducing me to Alyson's work, Wynn Kramarsky for his early support, and Derek Eller for his recent counsel and generosity. Special thanks to Mixed Greens and Derek Eller Gallery, both in New York, for their important loans to the exhibition, and to Socrates Sculpture Park, Muse X Editions, and Debra Singer for their cooperation and assistance. Bethany Johns designed this beautiful catalogue with new photographs by Arthur Evans, Oren Slor, and Fred Scruton.

At the Tang Museum, thanks to installation crew members Sam Coe, Torrance Fish, Chris Oliver, Patrick O'Rourke, Alex Roediger, and Joe Yetto. Thanks also to Tang staff Helaina Blume, Jill Cohan, Ginger Ertz, Lori Geraghty, Elizabeth Karp, Susi Kerr, Gayle King, Chris Kobuskie, Barbara Schrade, and Gretchen Wagner. Special thanks to Tyler Auwarter and Jefferson Nelson for their design and fabrication work. Also thanks to Skidmore faculty: Karen Kellogg, Michael Marx, and Kate Leavitt; and Barbara Melville, Mary Jo Driscoll, Barry Pritzker, and Elizabeth Marena for their support. Thanks to museum interns Rosie Garschina, Brendon Boyle, Rebecca Pristoop, and Kristen Coates for their enthusiastic assistance.

Lastly, Alyson Shotz deserves our greatest thanks for her trust and unfailing spirit of collaboration. She has worked on this project for more than a year through studio visits, phone calls, emails and site visits. She has edited texts, dug through archives, remade old work, and crafted new work that together has made this exhibition a great success—one that will be memorable for years to come.

—IAN BERRY, CURATOR

No work of mine would be possible without the support of so many people. First among them is George Lerner who keeps me going with humor, love, and infinite patience. Also my parents Lois and Marvin Weinberg and Fred Shotz who have always encouraged me. Many thanks go to the Tang Museum staff, who devoted themselves tirelessly to every detail of the exhibition. Also I am deeply indebted to many long time supporters who have believed in my work from early on: Carolina Nitsch, Jane Hart, Andrea Feldman, Starr Figura and, of course, Susan Inglett. Also, I am immensely grateful to Paige West, Heather Darcy and the staff of Mixed Greens whose enthusiasm and steadfast commitment is simply amazing. Thanks also to Derek Eller, Alyson Baker and Robyn Donahue at Socrates Sculpture Park, Tracy Adler, Debra Singer, Lee and Kelly Stoetzel, Beverly Reynolds, Wynn Kramarsky, Peter Norton and Regina Taylor, Kris Kuramitsu, Anne Ellegood and Beth Venn, Joseph Grigely, Tara Donovan, Phyllis Baldino, and Jonathan Van Dyke.

Finally, no thanks will ever be enough to Ian Berry, who has done so much to make this exhibition and catalogue possible. His intelligence, sensitivity, humor and generosity is unmatched and I feel very lucky to have had a chance to work with him.

—ALYSON SHOTZ

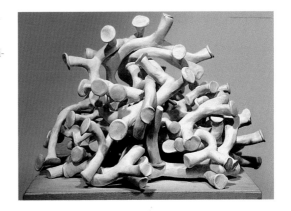

Branching Units, 2003
Sculpey, acrylic paint
Dimensions variable
Carolina Nitsch editions

This catalogue accompanies the exhibition

ALYSON SHOTZ: *A SLIGHT MAGNIFICATION OF ALTERED THINGS*

October 18–December 31, 2003

The Tang Teaching Museum and Art Gallery
Skidmore College
815 North Broadway
Saratoga Springs, New York 12866
T 518 580 8080
F 518 580 5069
www.skidmore.edu/tang

This exhibition and publication are made possible in part with public funds from the New York State Council on the Arts, a state agency, The Laurie Tisch Sussman Foundation, The Overbrook Foundation, and the Friends of the Tang.

ISBN 0-9725188-1-9
Library of Congress Control Number: 2003095379

Cover:
Mirror Fence, 2003 (detail)
Acrylic, wood, aluminum, hardware
138' x 36 x 4"
Courtesy of the artist
Installation view, *Yard: an Exhibition about the Private Landscape that Surrounds Domestic Architecture*, Socrates Sculpture Park, New York

page 1:
Grass Roll, 1998 (detail)
C-print
24 x 36"
Courtesy of the artist

Photographs:
Cover, pages 42, 49, 51: Oren Slor
Pages 4, 12, 24, 25, 41, 43, 59, 61: Fred Scruton
Pages 7, 20: Peter Muscato
Pages 15, 26, 27, 38–39, 45, 46, 47, 52, 54:
 Arthur Evans
Page 17: Kim Keever
Page 37: Anthony Cunha

Designed by Bethany Johns
Printed in Germany by Cantz